healing waters

THANK YOU TO / *TOUS MES REMERCIEMENTS À*
NATHALIE C. EMPRIN, GALERIE N.C.E., PARIS
CHRISTOPHE LÉGER, ÉDITIONS MARVAL, PARIS
MARCEL SABA AND DON STANDING, SABA GALLERY, NEW YORK
Dr WOLFGANG BECKER, DIRECTOR, LUDWIG FORUM FÜR INTERNATIONALE KUNST, AACHEN, GERMANY
Dr YVES TREGUER, DIRECTEUR, THERMES MARINS DE MONTE CARLO, MONACO
AGENCE VU, PARIS, GRAZIA NERI, MILAN
A.D. COLEMAN, THIERRY CORDIER LASSALLE
AND MY MOTHER / *ET À MA MÈRE*
MARION TROELLER
BUT ALSO / *SANS OUBLIER*
CAROL FONDE, MICHAEL SAND, HANNA IVERSON, EMMANUELLE BAJAC
LES EAUX DE VITTEL, BERNARD BERT ET I-SPA, MARION SCHNEIDER ET KLAUS DIETER BOEHM
MICKY REMANN, LIQUID SOUND, BAD SULZA, GERMANY
AND A SPECIAL THANK YOU TO ROBERT HUSZAR FOR INSPIRED EDITS
(FOR PHOTOGRAPHS CONTACT PHOTONICA, NEW YORK 212-505-9000)

ACHEVÉ D'IMPRIMER À ROME EN FÉVRIER 1997 PAR ALBAGRAF
ISBN 2-86234-236-X © MARVAL 1997

healing waters

linda troeller

Linda Troeller (signature)

preface
DR. WOLFGANG BECKER

introduction
DR. YVES TREGUER

aperture

Thank you to Robert Huszar, for continuing collaboration in editing and writing; to Nathalie C. Emprin, gallerist, Paris; Christophe Léger, Yves-Marie Marchand, Editions Marval, Paris; to Michael Sand at Aperture, who nurtured the project from early on; Leila Levy, Phototake, New York; Jerry Karpf, Photonika, New York; A. D. Coleman; Grazia Neri, Milan; Herbert Locher, Cologne; Princess Caroline, Monaco; Jay Hone, Neill Heath, Carole Fonde; David Friend, Vivette Porges, *Life* magazine; Anne W. Tucker; William Messer; Don Standing, Marcel Saba; Marion Schneider; Klaus Dieter Boehm; Mickey Remann, Bad Sulza Spa; Frank van Putten, Spa-finders; Bernard Burt, SpaGoer; Werner Mandel, New Age Spa; Jenni Lippa, Spa Trek, Kerstin Florian, Inc.; Kim Marshall, I-SPA; Marlene Powers, Cal-A-Vie Spa; Dr. Steven Margolin, my chiropractor; Sam Cagnina, my massage therapist; Dr. Steven Margolin's Wellness Spa, New York; Silvana Martinelli, my guide at Terme di Saturnia; Reike, therapist and friend; and my mother.

Jacket design by Wendy Byrne

Library of Congress Catalog Card Number: 97-75179

Photographs copyright © 1997 by Linda Troeller. First Edition USA (Hardcover): ISBN 0-89381-770-8 © Aperture 1998. First Edition France (Relié): ISBN 2-86234-236-x © Marval 1997.

Aperture Foundation publishes a periodical, books, and portfolios of fine photography to communicate with serious photographers and creative people everywhere. A complete catalog is available upon request. Address: 20 East 23rd Street, New York, New York 10010. Phone: (212) 598-4205. Fax: (212) 598-4015. Toll-free: (800) 929-2323.

Aperture Foundation books are distributed internationally through: CANADA: General Publishing, 30 Lesmill Road, Don Mills, Ontario, M3B 2T6. Fax: (416) 445-5991. UNITED KINGDOM, SCANDINAVIA, AND CONTINENTAL EUROPE: Robert Hale, Ltd., Clerkenwell House, 45-47 Clerkenwell Green, London EC1R OHT. Fax: 171-490-4958. NETHERLANDS: Nilsson & Lamm, BV, Pampuslaan 212-214, P.O. Box 195, 1382 JS Weesp, Netherlands. Fax: 31-294-415054.

For international magazine subscription orders for the periodical *Aperture*, contact Aperture International Subscription Service, P.O. Box 14, Harold Hill, Romford, RM3 8EQ, England. Fax: 1-708-372-046. One year: £30.00. Price subject to change.

To subscribe to the periodical *Aperture* in the USA write Aperture, P.O. Box 3000, Denville, NJ 07834. Tel: 1-800-783-4903. One year: $40.00.

First edition USA
10 9 8 7 6 5 4 3 2 1

preface

When I discovered Linda Troeller's photographs I was struck by their symbolic nature. Their meanings are only partially to be found in what these images represent, as they exist in a metaphorical space of significance. Linda Troeller does not take her photographs underwater, but numerous close-up pictures let you forget the border between air and water: the human being unites with the water in such a manner that he is swallowed up by it. Or he rises shadowy within vapors of hot water, as if materialized from the state of dissolution into another state of vague corporeality.

Linda Troeller often searches the close-up and the flowing movement in such a manner that marries the human being and water in a state of ecstasy. There is an element of shamelessness in this, an element that has never appeared in photographs of bathing people; shame and reservation have been removed, the security of knowing that the ecstasy is drawing to a close, and has been surrendered. Colors and shapes in the photographs assume the expression of oceanic drunkenness: the light breaks quicksilver on the water surfaces, bodies light up in fiery red-orange; bodies materialize slowly in the flowing surface of the photograph.

Linda Troeller's desire to express herself is concentrated on health resorts throughout the world; but it would be wrong to call her a collector: the names of the places where her pictures were taken are of minor importance and are secondary to the generality of her attitude. In her photographs of water, she has discovered a picture of human experience which is organic, blurred, warm, comfortable, mysterious, holistic, and emergent.

—*DR. WOLFGANG BECKER*, DIRECTOR
Ludwig Forum fur Internationale Kunst,
Aachen, Germany

introduction

On our blue planet, the movement of waters is an infinite cycle; the sea its alpha and omega. Throughout time and under all latitudes, bathing in water has been both a purifying ritual and a ceremony of introduction to all varieties of religious truth. But modern public baths are no longer the temples in which the Greeks and Romans worshipped.

A century ago, the French scientist René Quinton established the physiological similarity of sea water and of blood plasma, forever marrying in concept the sea to health. Consequently our civilization, saturated with noise and speed, felt the need to reinvent the bath as a source of solitude and renewal. In water the body is freed and surrenders itself, becoming more beautiful, more slender, more supple in the grace and equilibrium of this pristine element. Our body is but a mere envelope we cast off as we might a suit of armor made of stress and fear.

Water is the ultimate medium; besides its life-giving properties, it possesses the qualities of photographic developer, capable of reflecting naked man while its transparency is a connection to the interiors. And it is in its interior, this center where our water-filled cells go about the minutia of renewal, this twilight where our over-burdened psyche finds repose, where Linda Troeller's photographs will lead you. With color and blurred motion, she has made visible those hidden spaces where water seeps in with its power.

—*DR. YVES TREGUER,* DIRECTOR
Monte Carlo Thermal Baths, Monaco

spa stories

GELLERT BATHS, BUDAPEST, HUNGARY

Standing in the shower, I imagined my father waving his leg beneath him, using the undulating shoreline to hypnotize himself, while gaining peace from the water rippling over his foot. It took seven minutes of unbandaging to put the foot in the water. My father's left heel had been shot off in '44—mid-winter at the Ziegfried line. He had used his clothing as a tourniquet. The worst was the hospital—eighteen months, thirty-six hundred shots of penicillin. They gave him a brace. He could only be free of it when we went to lakes and springs. When you're deeply wounded, you either grow or die. "Who knows," asked Wordsworth, "the hour of the deed in which one's habits are sown for the rest of life." In this place I found why I was following the waters.

CONTREXEVILLE, FRANCE

A monk told me that the body is a source of transcendence. He had begun experimenting with water therapies. In changing the physical body he had radically changed his idea of spirituality. In cleansing himself, he was cleansing the Earth.

HARBIN HOT SPRINGS, CALIFORNIA

During Watzu sessions, I feel how the buoyancy of water holds and supports the body, while the mind becomes still. The isolation is like returning to the womb, carrying the body to a state of rapture.

FLOATING CULT, HARBIN HOT SPRINGS, CALIFORNIA

Dr. David Baines told me the legend of a great lake in Kiowa territory. The Indians went to the waters to receive gifts of the Spirit. For four days and nights they would wait for its message. "Some times the water would boil and roar and test them. If you haven't got the courage to receive the Spirit and you get scared and run off, you don't get it. You have to hold your ground if you want the Spirit."

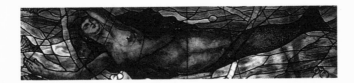

LIQUID SOUND, BAD SULZA, GERMANY

In a perfectly balanced saline pool I was bathing in underwater music and laser light. The songs of the Orca bubbled around me. I opened my eyes and found the other participants gathered like schools of fish, gliding on the surface, resting and sinking into deep blue, red, and green hues of light. My body yearned to dance with the others. A yellow sun covered my face and a vision of whiteness followed.

CARSON HOT SPRINGS, NEVADA

In ancient civilizations temples were built over hot springs, the waters a lubricant for the soul and body. In my own bath I saw how water could provoke visions and passions.

OJO CALIENTE HOT SPRINGS, NEW MEXICO

A woman arrives after a year of back paralysis with no cure from modern medicine. After three weeks in the baths, she takes her first step. A drugged-out rock drummer is clear after a month's retreat; and a ninety-seven-year-old man claimed drinking the water for the past thirty years was responsible for his longevity. The stories escalate when the Dalai Lama arrives.

TERME DI SATURNIA, ITALY

Sally Mann once wrote me about her childhood house next to the hot springs in Virginia. "I always thought it somehow miraculous that I could stand in the window of the house, beside the most exquisite bijou Cézanne, and watch my mother reading, her cigarette held at the farthest bony tip of her fingers, and sense the waters giving off their cure."

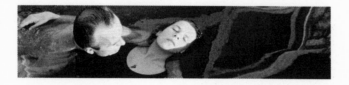

BADEN-BADEN, GERMANY

Water valorizes qualities of skin tone, self-assurance and dignity. In German culture the bath is an affirmation process. A narcissistic attitude is part of the adoration of water.

CALISTOGA HOT SPRINGS, CALIFORNIA

A Wicca priestess took me to buy a small amulet. It contained the powdered bones of women who died before their time. We performed an ancient ceremony, rubbing the powder on our bellies and jumping into a mineral pool to return their souls to the waters. In the waters their spirits were released and granted wishes.

THERMES, AIX-LES-BAINS, FRANCE

The fifth-generation spa doctor François Forestier, whose great-grandfather had received sponsorship by Napoleon, took me to an ancient Roman bath and showed me the source of their hot spring. For centuries this mineral water had been flowing deep inside the earth in vents and crevices, ascending and cooling in rock layers. "How long will it take us to recover what the Ancients really knew about healing with water? French people don't fear germs as much as they fear chemicals. Americans fear germs but not chemicals. Your water is chlorinated in such high doses that it is pillaged of its essential life."

SAN JOSE PURUA HOT SPRINGS, MEXICO

Jacques Lacan, speaking about love, used to tell the story about dancers at a Venetian ball and the climax when the lovers remove their masks. It's that moment when you truly see. My moment came in the thermal waters of some make-believe canal, looking at the gondolas on which I saw the faces of desperate pilgrims with their masks off. I did not see the reflection of the young girl in the fountain, as promised, but I did feel myself reborn.

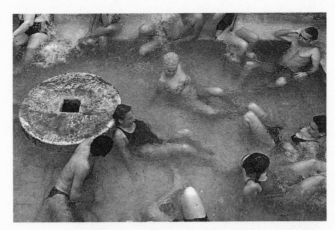

THERMES MARINS, MONTE-CARLO, MONACO

*D*uring the prehistoric era, land was open space, and so the vastness of the ocean is an archetype that is reassuring to us.

SEA CAVE, ITALY

*A*t a goddess gathering in a cave, we were exploring how water was synonymous with fertility and power in pagan culture. The site was considered a holy place. During the rite, we submerged ourselves in the surf. We were remineralizing ourselves, partaking of elements modern civilization has robbed from us. At one point, as the waves were crashing over me, I became very aroused. A doctor who later saw the photographs told me he had been using orgasm to improve the immune system in women with advanced cancer.

SACRED WATERFALL, HARBIN, CALIFORNIA

*S*he wore the mark of Isis in a pink and green tatto that covered her back. She told me she was a priestess in another life, and that the Goddess had a quintuple personality encompassing birth, intuition, consummation, repose, and death. Her quest was ineffably beautiful moments in nature, a spiritual orgasm.

MEDICINE WHEEL POOL, BREITENBUSH HOT SPRINGS, OREGON

*T*he moon was full as she stripped from her clothes to dance naked on the soft pine floor. The herbs she had scattered were releasing their essences, mingling with the vapours. The woman sang out an invocation to Giver-of-Rain and Giver-of-Rain heard, sending new rain down to earth.

—LINDA TROELLER

Perhaps one witness telegraphs the image to many.

—*ANNE RICE*

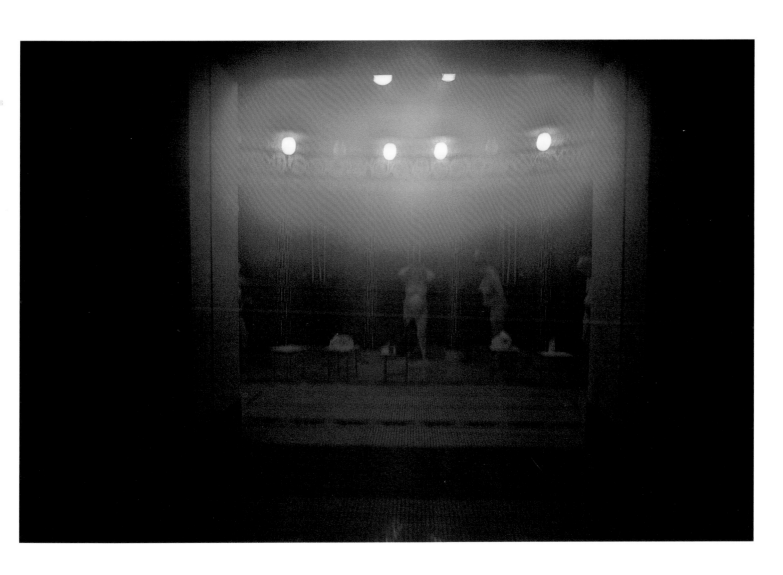

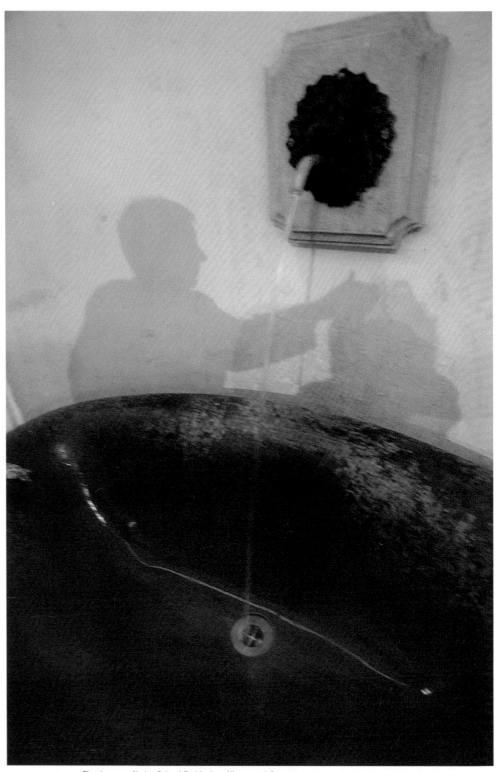

Eisenbrunnen, Aix-les-Bains / *Bad Aachen*, Allemagne / *Germany*

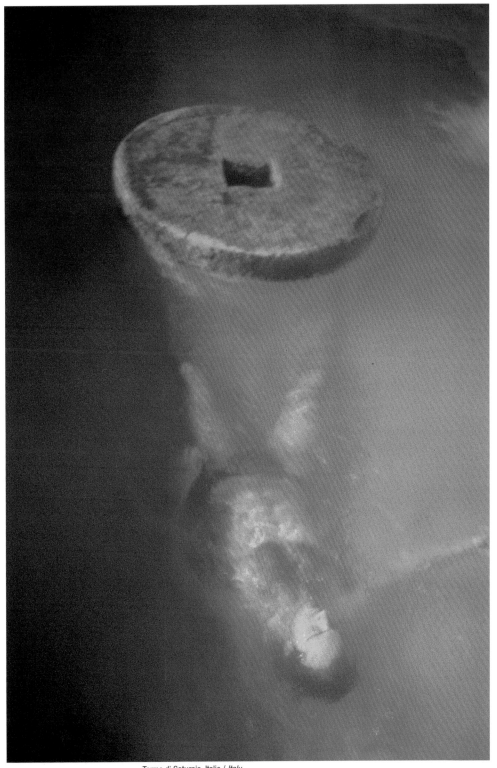

Terme di Saturnia, Italie / *Italy*

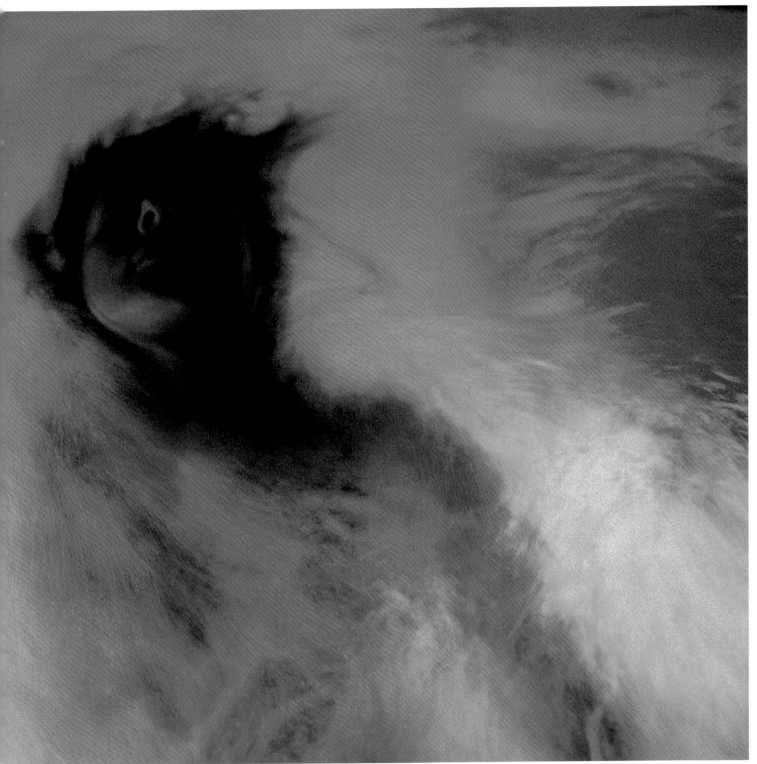

Jacuzzi, Calistoga Hot Springs, Californie / *California*

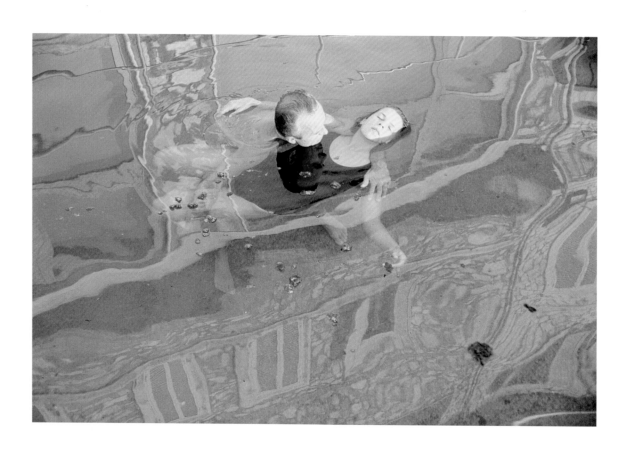

Terme di Saturnia, Italie / *Italy*

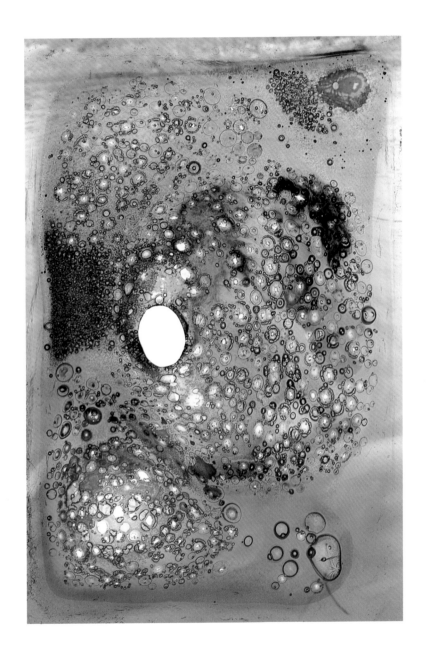

Rivière chaude / *Hot River*, Toscane / *Tuscany*, Italie / *Italy*

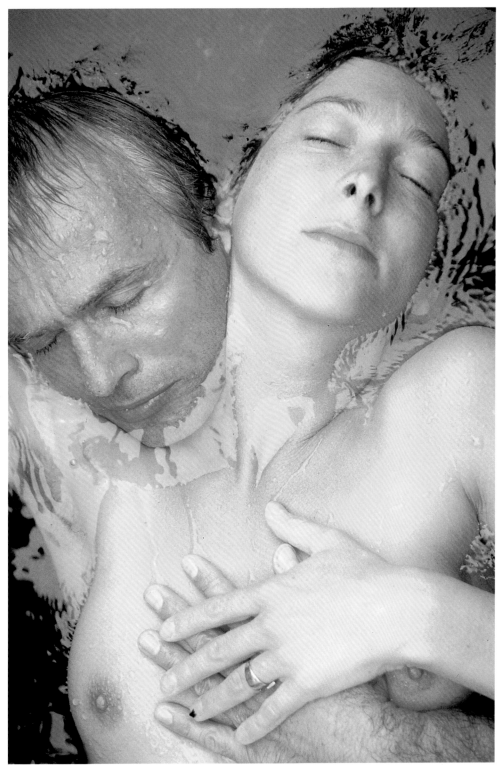

Dr Gunter Freude, Terme di Saturnia, Italie / *Italy*

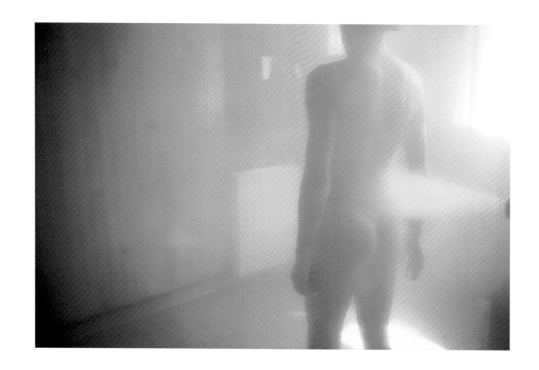

Contrexéville, France

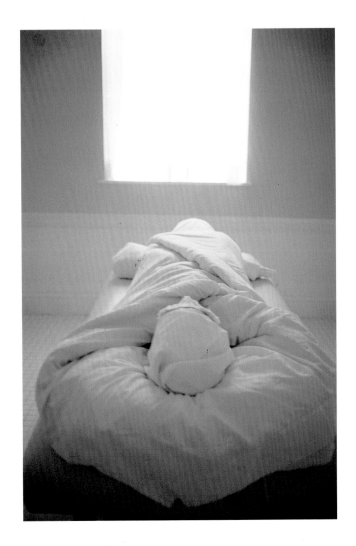

Enveloppement d'algues / *Seaweed Wrap*, Greenbrier Hotel Spa, White Sulphur Springs, West Virginia

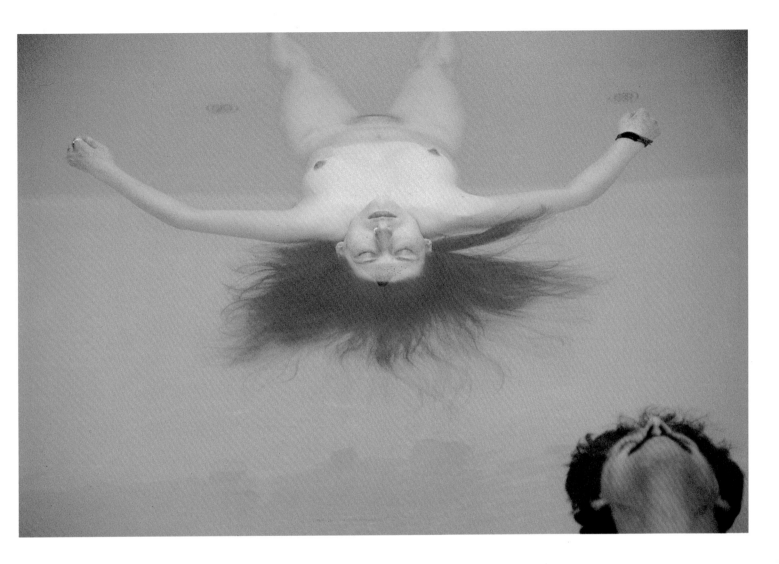

Musicothérapie / *Liquid Sound*, Bad Sulza, Germany

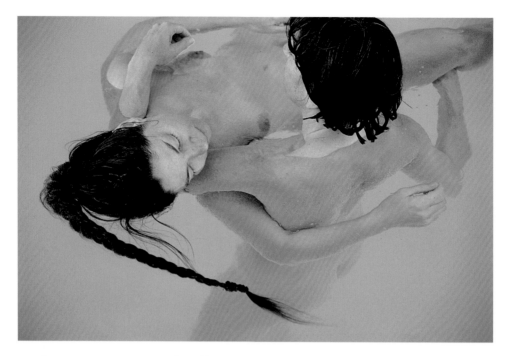

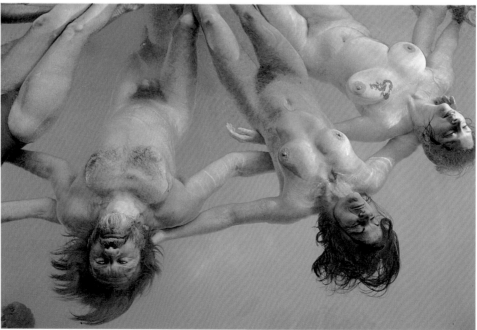

Magie de l'apesanteur / *Floating Cult*, Harbin Hot Springs, California

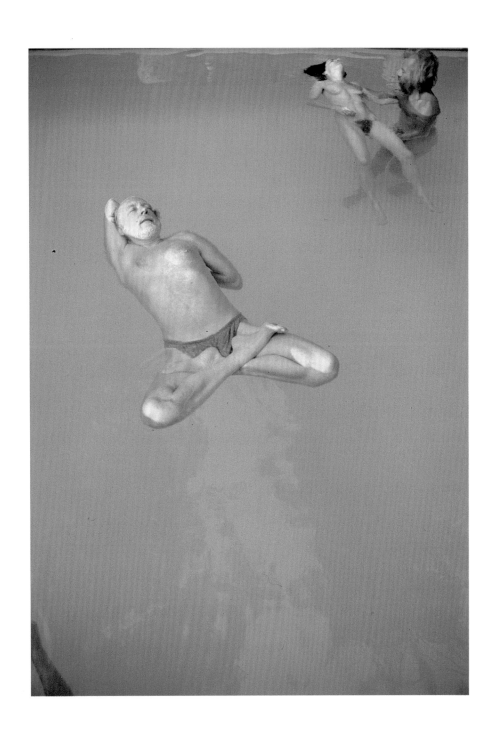

Harold Dull, Creator, Woga, Harbin Hot Springs, California

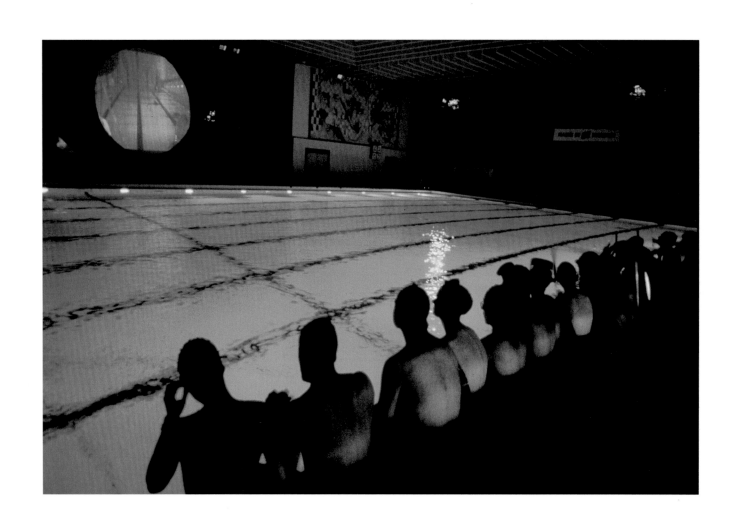

Concert subaquatique / *Underwater Concert*, "Incorpus", by Michel Redolfi, Toulouse Pool, France

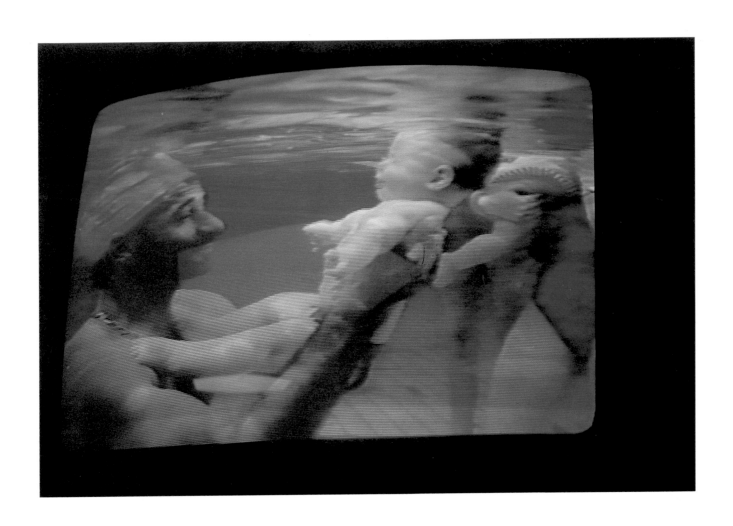

Cure jeune-maman / *Mother-Father-Baby Program*, Evian-les-Bains, France

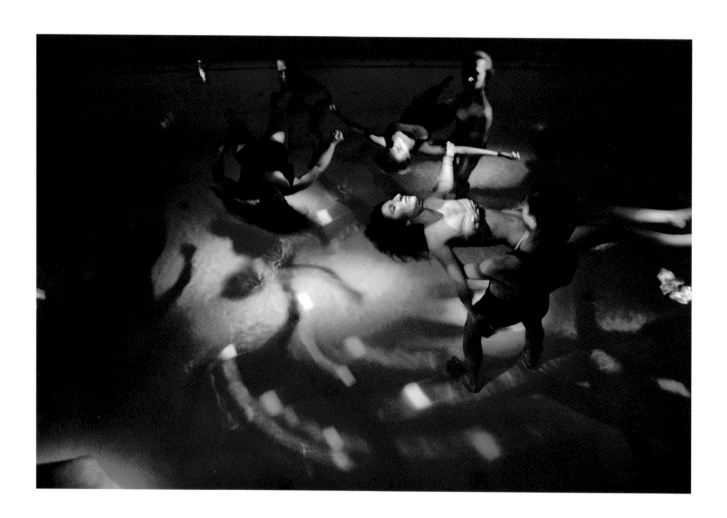

Musicothérapie / *Liquid Sound*, Bad Sulza, Germany

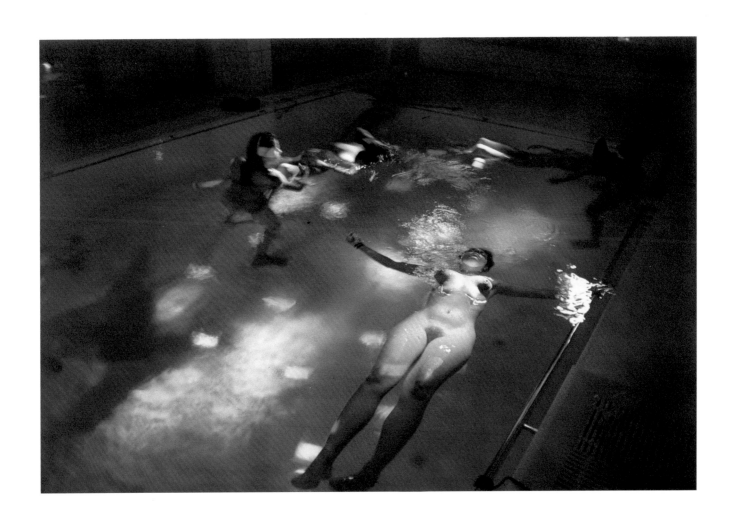

Musicothérapie / *Liquid Sound*, Bad Sulza, Germany

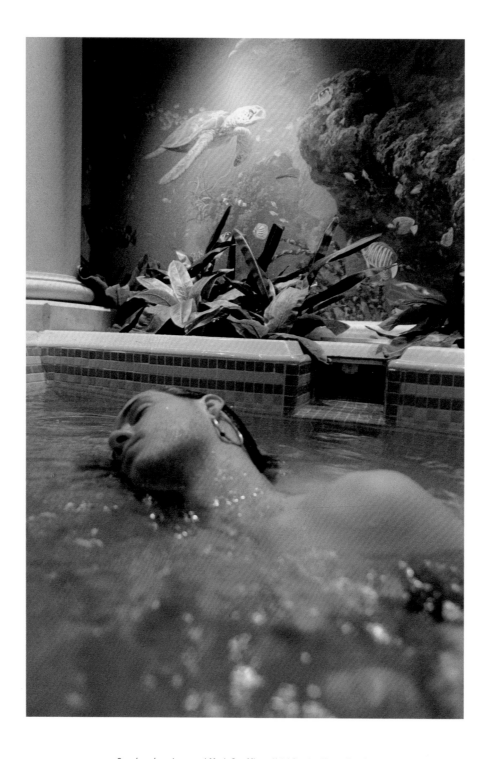

Spa réservé aux hommes / *Men's Spa*, Mirage Hotel Spa, Las Vegas, Nevada

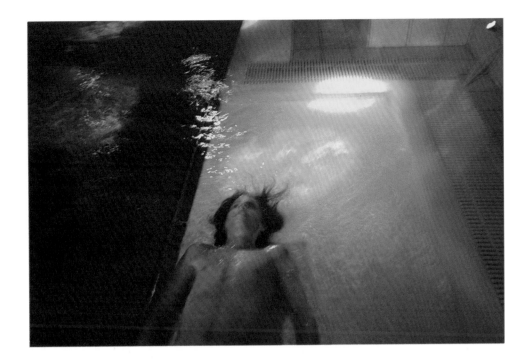

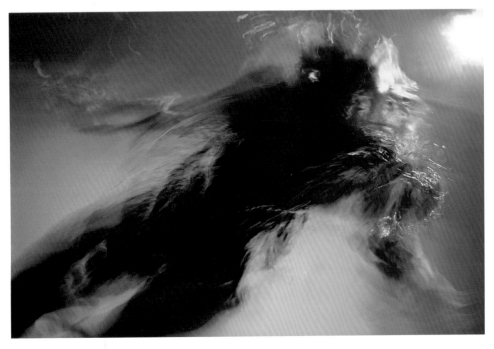

Personne handicapée / *Paralyzed Person*, Thermal Hotel Baths, Budapest, Hungary

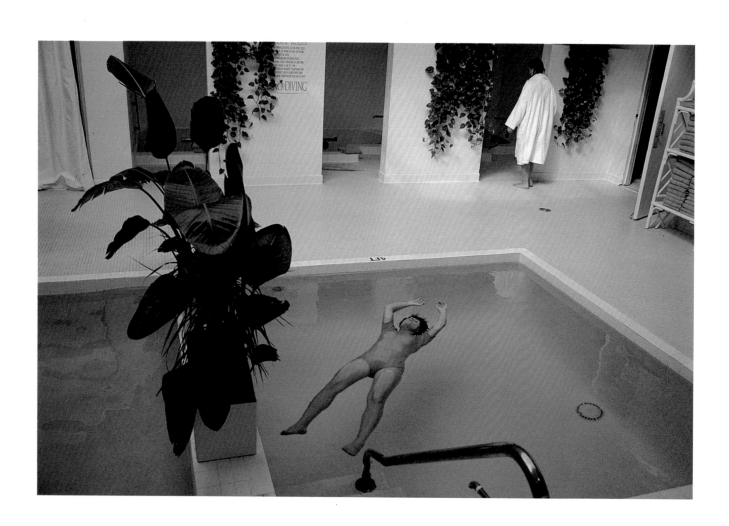

Palmaire Spa, Florida

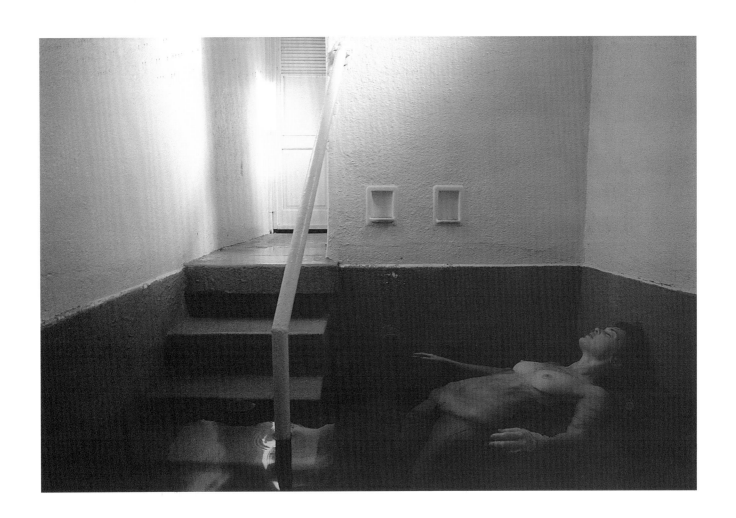

Carson Hot Springs, Nevada

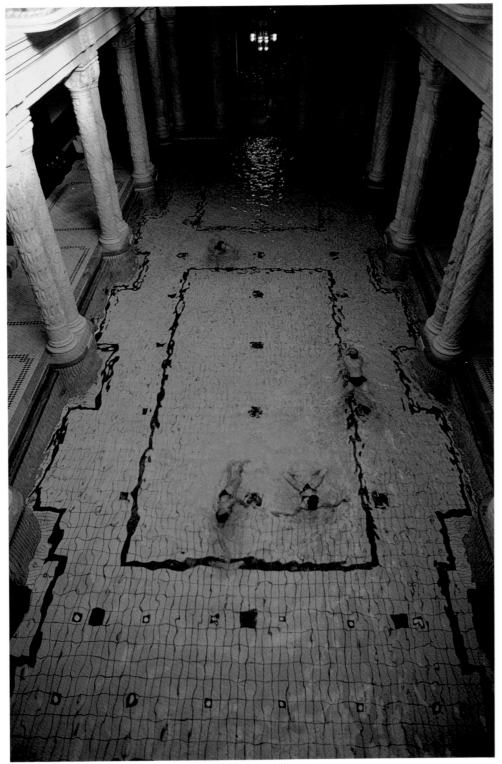

Gellert Baths, Budapest, Hungary

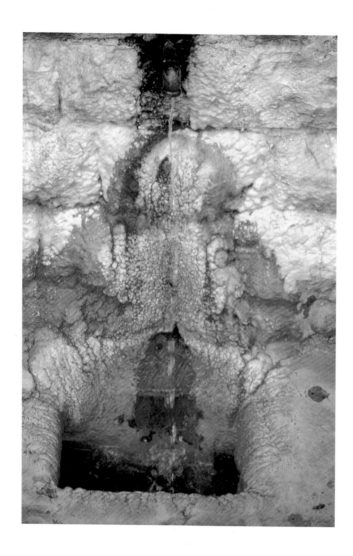

Source thermale / *Mineral Fountain*, Saratoga Hot Springs, New York

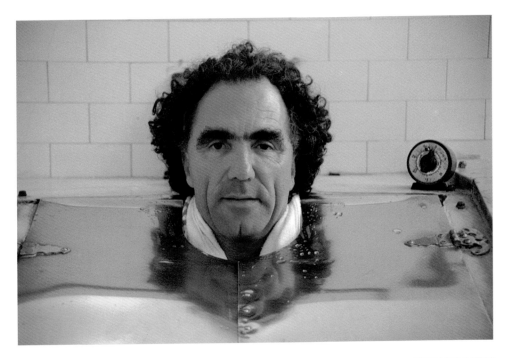

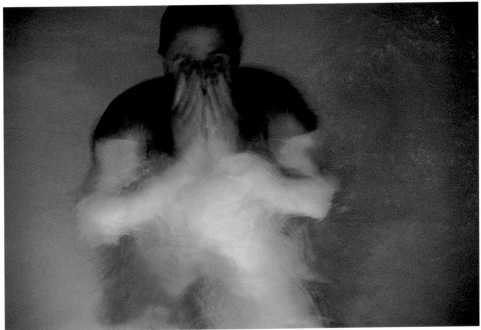

Kurbad Quellenhof, Bad Aachen, Germany

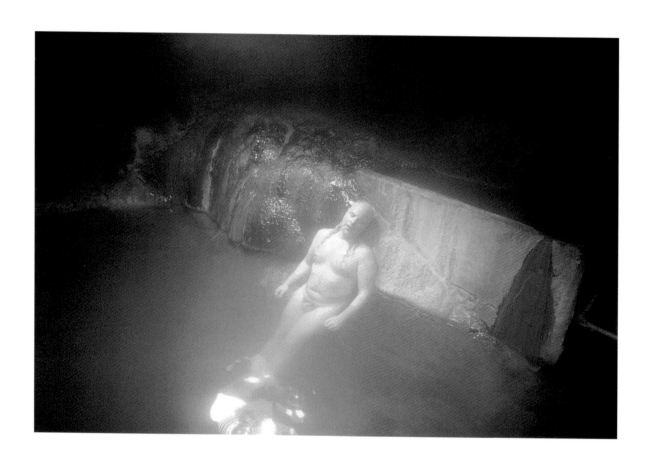

Piscine pour hommes / *Men's Pool*, Ojo Caliente Hot Springs, New Mexico

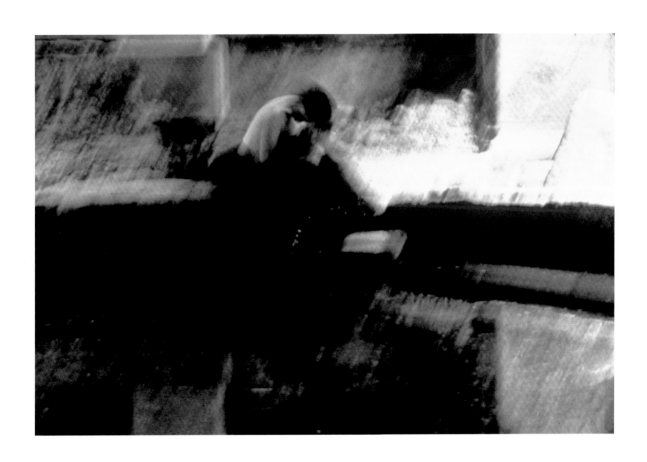

Bain sacré / *Sacred Pool*, Bath, England

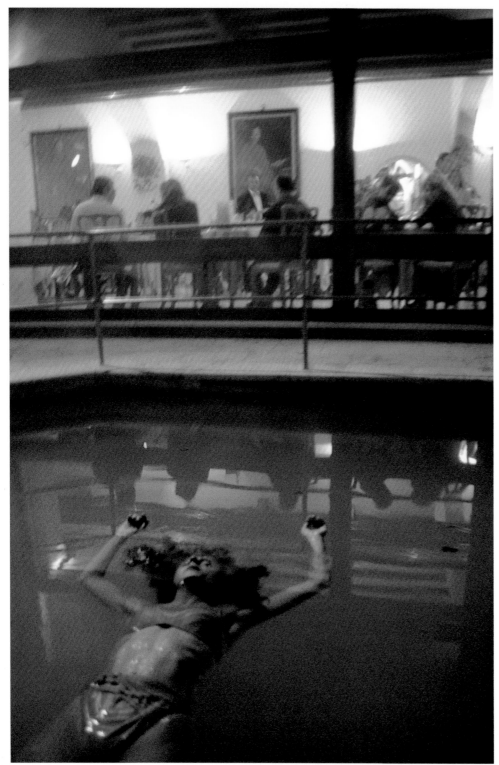

Terme di Saturnia, Italy

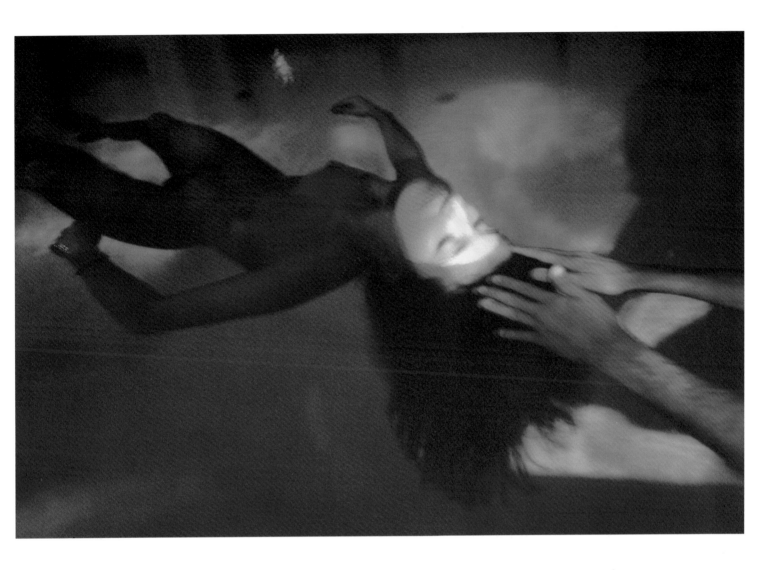

Massages aquatiques / *Waterbalancing*, Bad Sulza, Germany

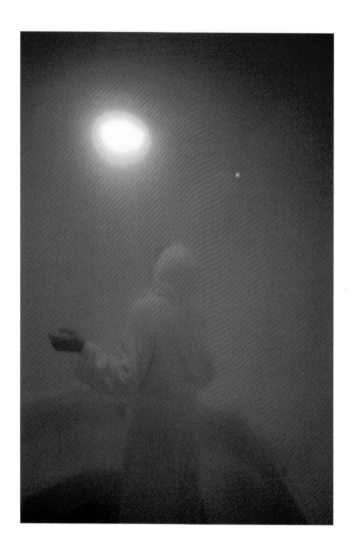

Sauna, Brenner's Park Hotel, Baden-Baden, Germany

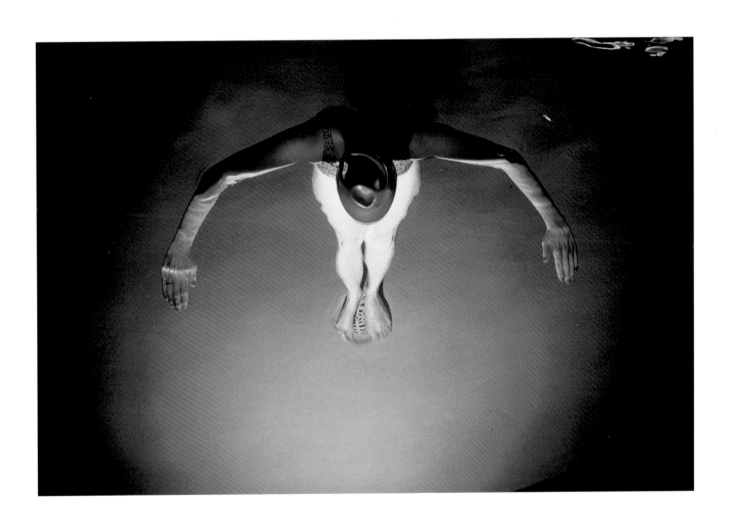

Baden-Baden, Germany

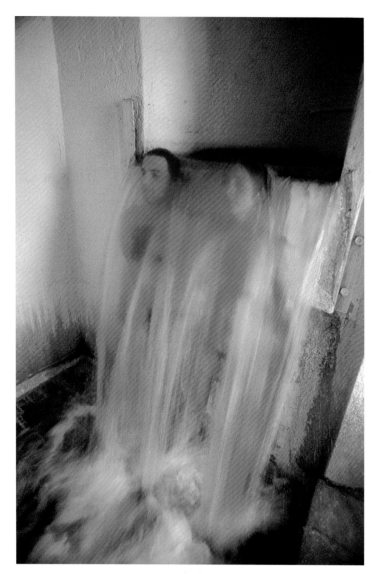

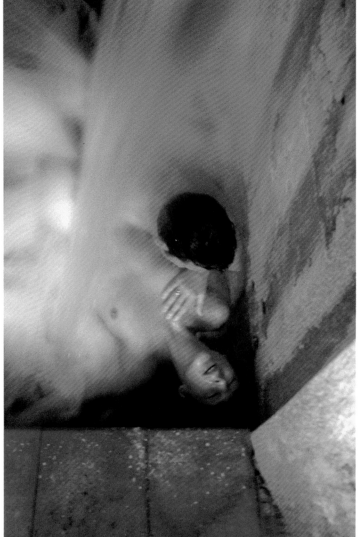

Sources chaudes / *Hot Waterfall*, Italy

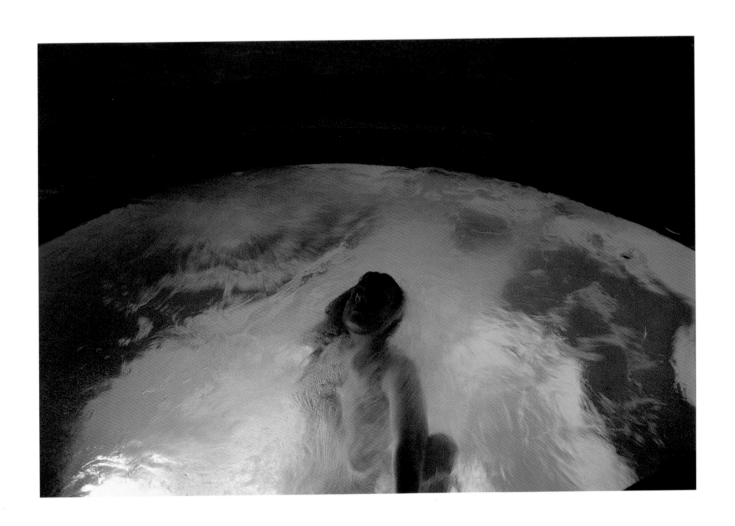

Calistoga Hot Springs, California

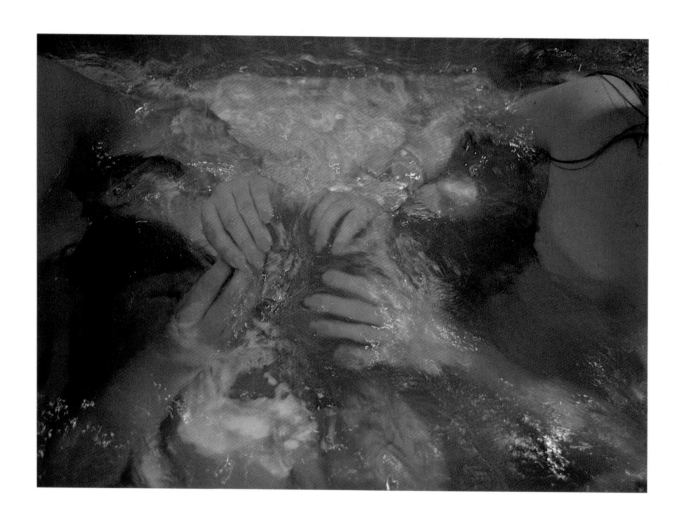

Thermes, Aix-les-Bains, France

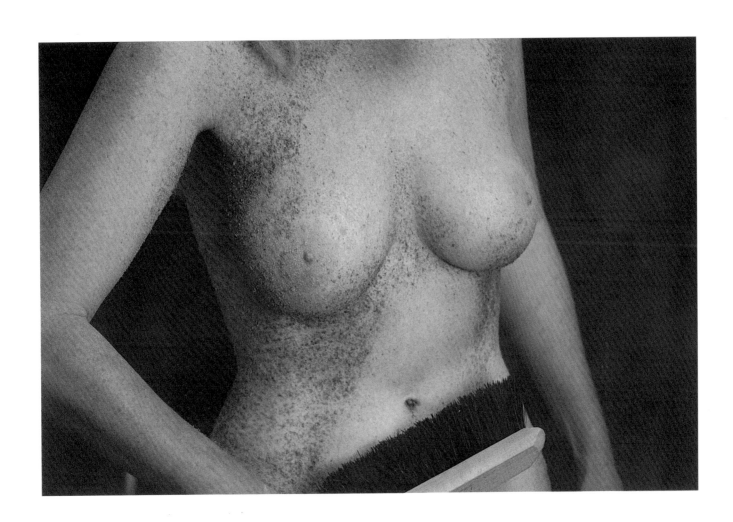

Boue / *Mud*, Mer morte / *Dead Sea*, Israel

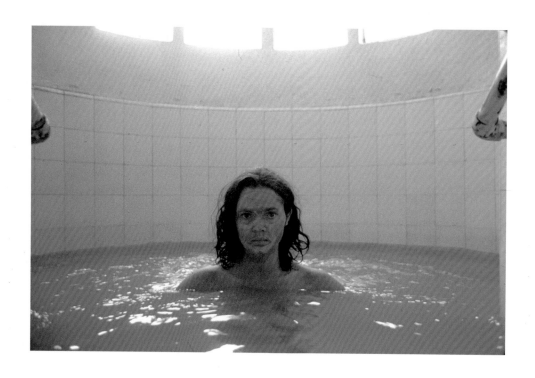

Autoportrait / *Self-Portrait*, San Jose Purua Hot Springs, Mexico

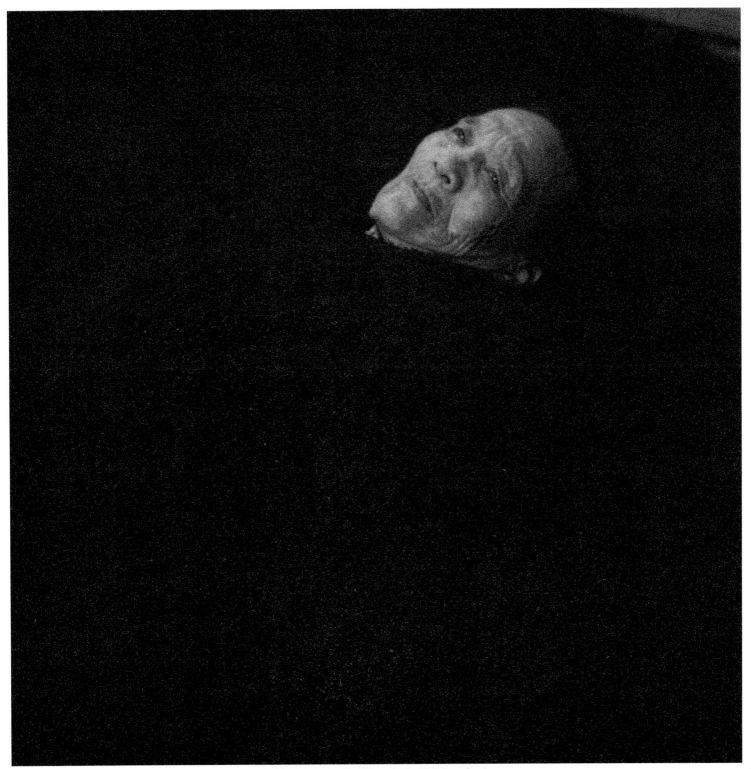

Arénothérapie, bains de sable / *Takegawara Sand Bath*, Beppu Spa, Japan

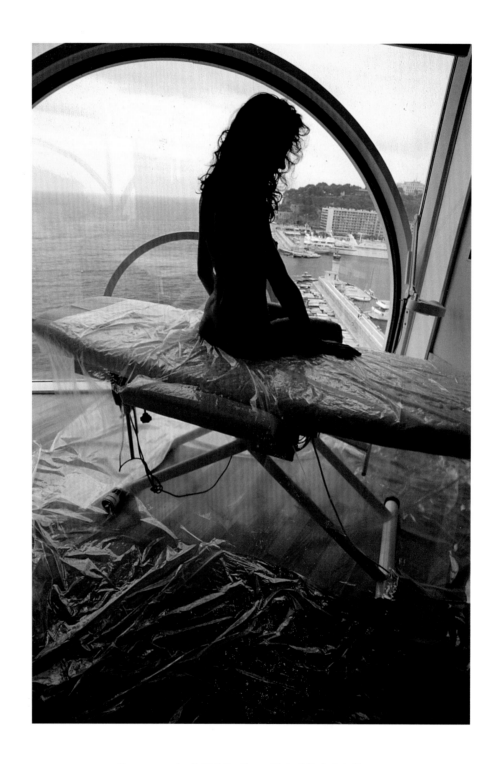

Gommage aux sel marin / *Salt Glow*, Thermes Marins de Monte-Carlo, Monaco

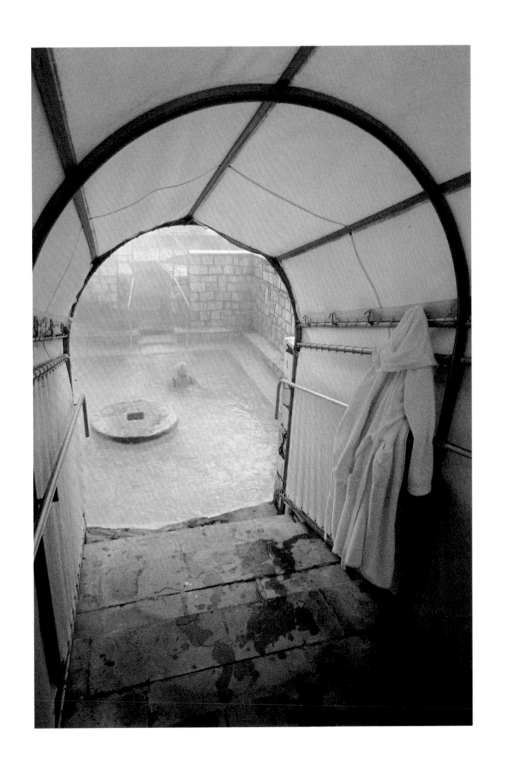

Terme di Saturnia, Italy

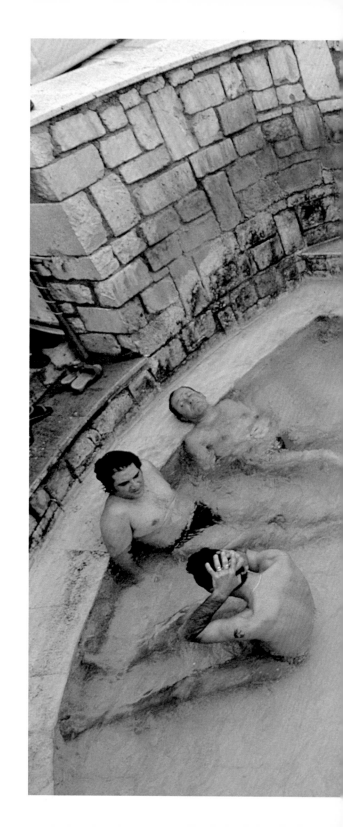

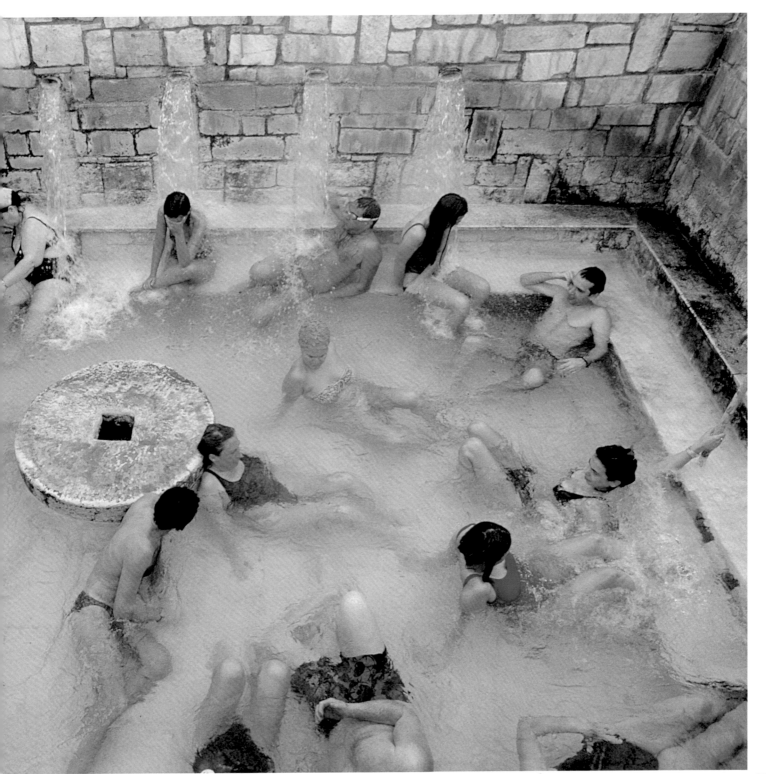

Cascade, Terme di Saturnia, Italy

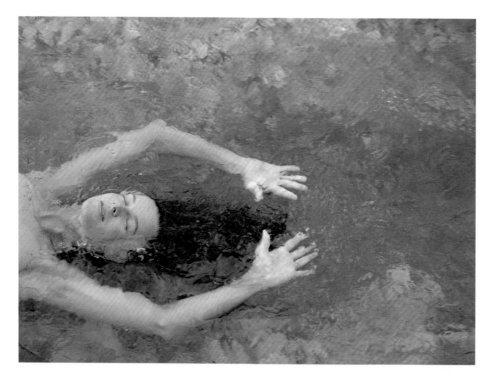

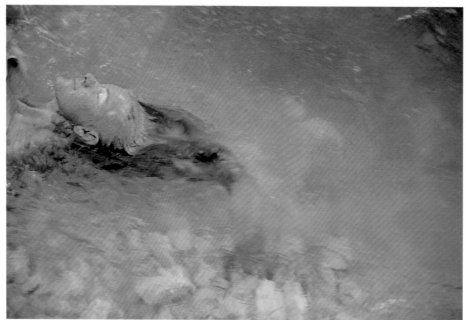

Application de boue / *Fango*, Terme di Saturnia, Italy

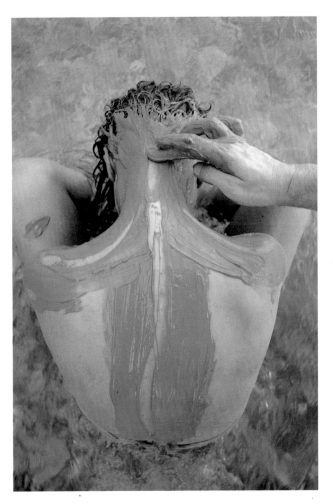

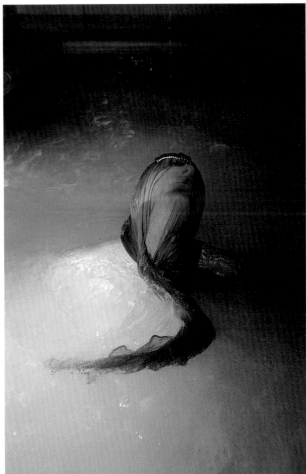

Application de boue / *Fango*, Terme di Saturnia, Italy Bain bouillonnant à l'eau de mer / *Seawater Jacuzzi*, Gurney's Inn & Spa, Montauk, Long Island

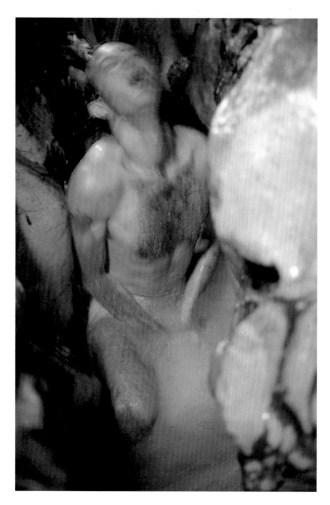

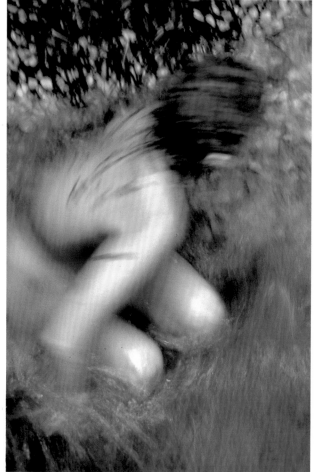

Grotte marine / *Sea cave*, Italy

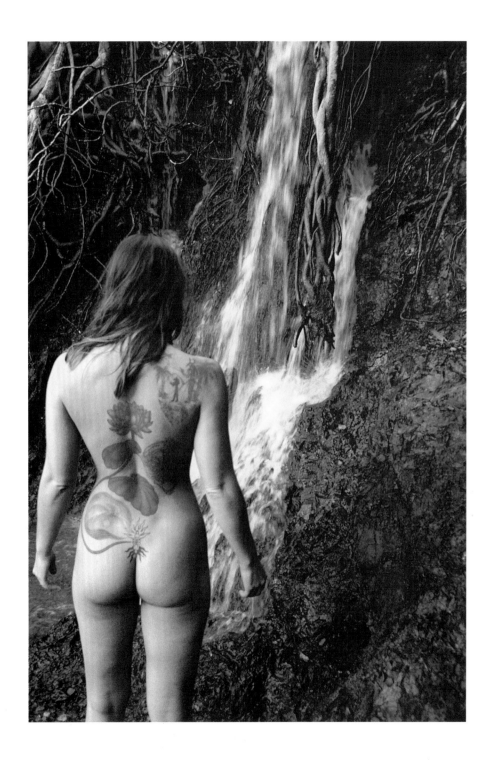

La déesse des sources / *Sacred Waterfall*, Harbin Hot Springs, California

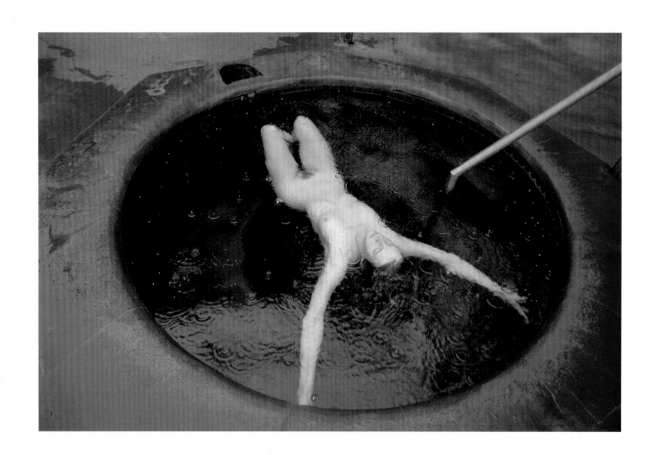

Breitenbush Hot Springs, Oregon